OUR LOVE OF
Bees

Jaret C. Daniels

Adventure Publications
Cambridge, Minnesota

Dedication

To my lovely wife Stephanie. She is my colleague, best friend, and the only person with whom I could ever imagine sharing my life.

Edited by Brett Ortler

Cover and book design by Lora Westberg

Front cover photo: Honey Bee by **Ikordela**/Shutterstock.com

Back cover photo: Milk Thistle by **Meena Meese**/Shutterstock.com

All photos used under license from Shutterstock.com:
Ant Cooper: 8, **bluedog studio:** 30, **Daniel Prudek:** 4, **Giles Kent:** 26, **HaiGala:** 50, **Ian Dyball:** 38, **Ikonoklast Fotografie:** 18, **Iryna Loginova:** 32, **Jennifer Bosvert:** 36, 42, **Kai Brosinski:** 52, **LedyX:** 28, **Lehrer:** 22, **lop5712:** 12, **Magdalenawd:** 10, **Mauricio Acosta Rojas:** 6, **Natfu:** 45, **Norjipin Saidi:** 46, **Ratikova:** 21, **Ruth Swan:** 34, **Sentimental Photos:** 54, **Simun Ascic:** 16, **StGrafix:** 40, **SweetCrisis:** 49, **TippaPatt:** 24, **Zlatkozalec:** 14

OUR LOVE OF
Bees

Beauty on a Small Scale

Like most other insects, bees are often overlooked and misunderstood. When viewed up close, these small creatures are really quite beautiful. While we tend to lump all bees together, they are an incredibly diverse group of insects and are found in a variety of sizes and colors. They also display a myriad of different behaviors, all of which are fascinating. Closely related to ants and wasps, bees are active fliers that have an exceptional fondness for flowers. With each intentioned visit, they help to ensure a healthy and productive world for all of us.

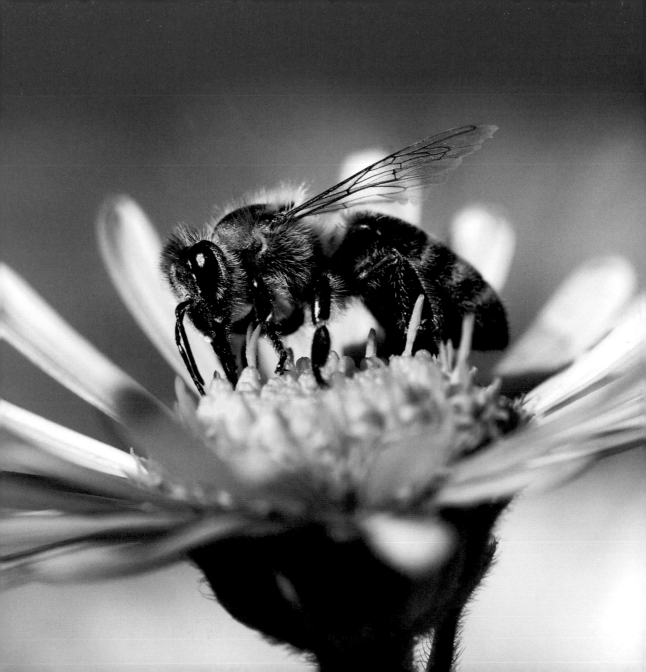

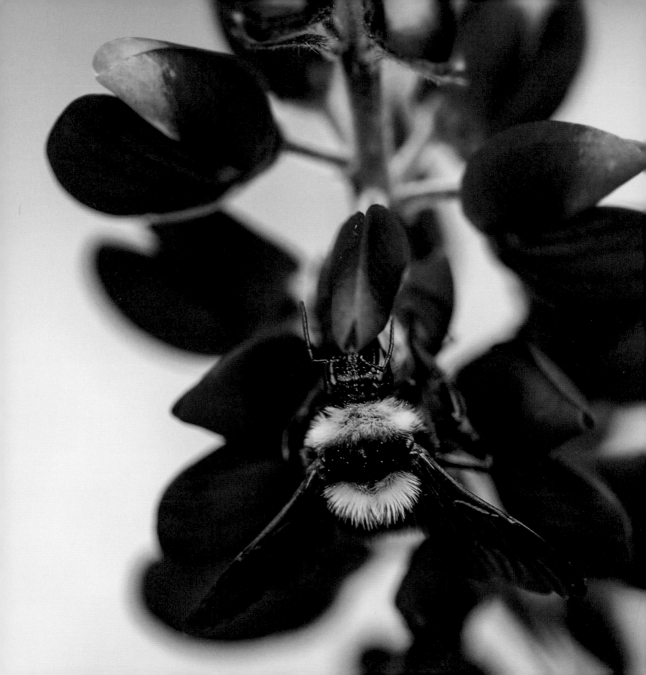

What's All the Buzz About?

Nearly 80 percent of all flowering plants on Earth rely on animals for pollination, with insects doing most of the heavy lifting. Bees, butterflies, beetles, and other insects move pollen from one blossom to another, enabling flowering plants to produce seeds and fruit. This essential ecosystem service provides us with food, fiber, and medicine, and, helps power our economy.

Bees are particularly industrious pollinators. With almost boundless energy, they meticulously scour the landscape in search of flowers, often traveling several miles in their pursuit. Most actively collect pollen and nectar with each flower visit. These vital floral resources serve as the primary food for both adult bees and their young.

Social or Solitary?

It's a common misconception that all bees live in colonies. In fact, the highly organized social communities formed by honeybees are an exception, not the rule. While bumblebees and some sweat bees do form small seasonal colonies, the vast majority of native bees worldwide are solitary. As these bees do not have a colony to defend, they are typically non-aggressive or may lack the ability to sting altogether.

Honeybees, of course, are famous for their large colonies, which may comprise tens of thousands of individual bees and which may persist for several years. These are akin to large cities. The bees in such colonies perform complex tasks, have a clear division of labor, and cooperate in food gathering, offspring care, and nest maintenance.

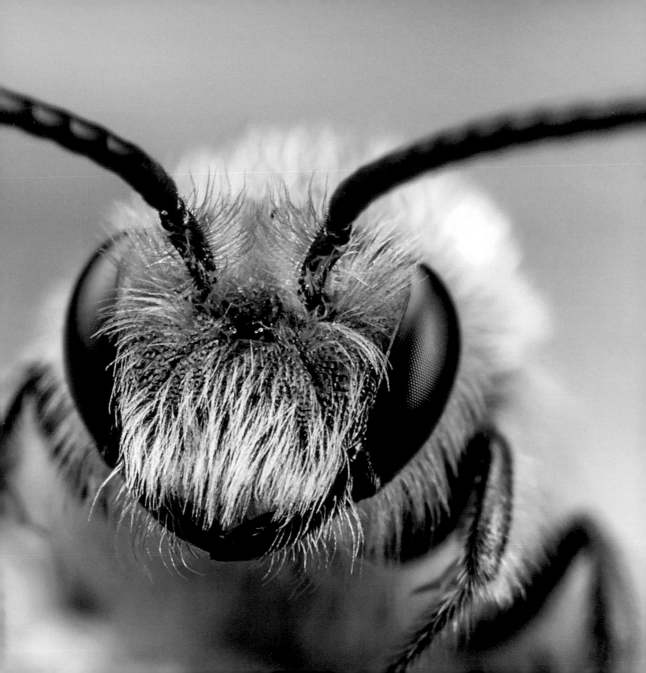

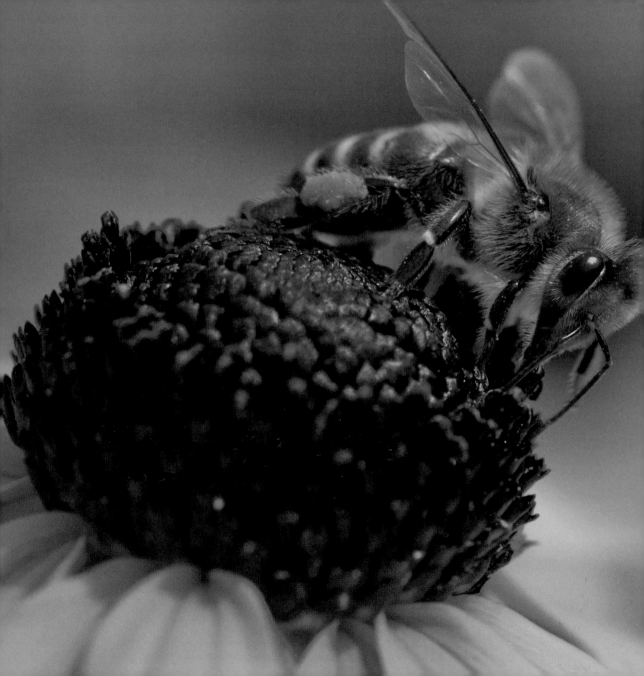

The Western Honeybee (Domesticated)

Humans have been consuming honey for at least 10,000 years, first from honey found in the wild, and later, from honey produced by domesticated honeybees. Domesticated honeybees (think bees raised in man-made hives) date back to perhaps 4,500 years ago, but possibly much earlier; along with the silkmoth, they were among the first insects to be domesticated. Once bees were domesticated, beekeeping spread widely, and so did honeybees. Early European settlers brought these beneficial insects to North America in 1622. Since then, many agricultural crops that rely on honeybees for pollination have also been introduced.

Today, the western honeybee, or "European" honeybee as it's commonly called, is one of the most recognizable insects in the world. It is a single species *(Apis mellifera)* with many races, more than 20 altogether that can readily hybridize with one another. Although their native range spans Europe, Africa, and the Middle East, western honeybees have become widely naturalized and today can be found on every continent except Antarctica.

Small, but Mighty, Pollinators

Despite their small size, honeybees have a monumental impact on the planet. They are critical to modern agriculture, helping ensure food security for an ever-growing population, and contributing billions of dollars each year to our economy. Recent studies also indicate that honeybees are the single most important pollinator in natural ecosystems.

Within the U.S., honeybees are linked to the production of more than 90 commercially grown crops, including cherries, melons, blueberries, and almonds to name just a few. In other words, without honeybees and other helpful insect pollinators, our daily mealtime would look and taste much different, and cost a lot more.

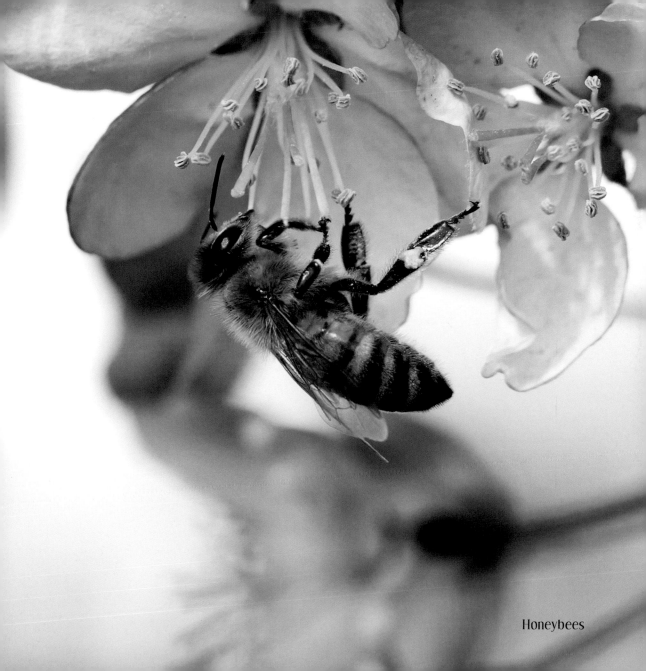

Honeybees

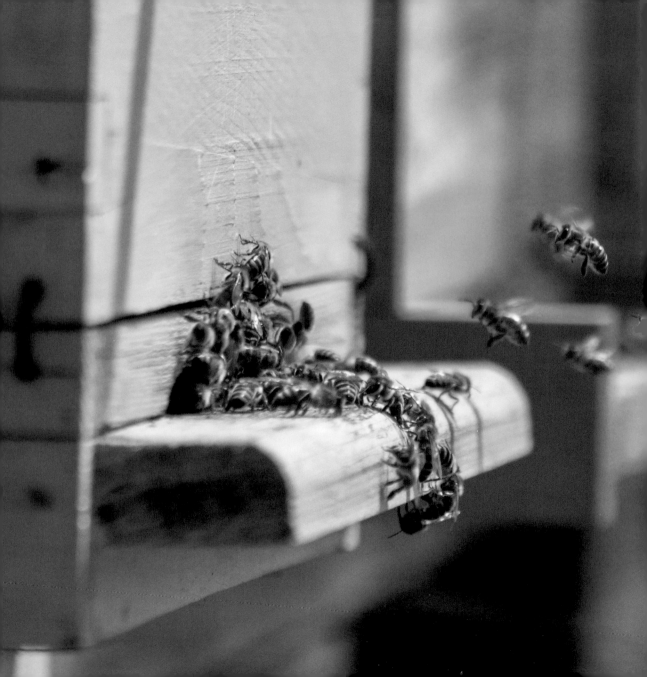

Cross-country Travelers

At any given point in time, there are over 2 million managed honeybee hives in the U.S. They are the bee of choice for farmers growing many fruit and vegetable crops, and they have become a big business. Farmers pay beekeepers to place hives in their fields. The hard-working bees in turn help pollinate the crops, optimizing yields and ultimately improving profits.

Each year, the bees literally follow the crops as each comes into bloom; beekeepers move the hives via truck by cover of night from one location to another. This involves complex logistics, a lot of physical labor, and often thousands of miles of travel to transport hives across the U.S. in service of the many fruit, vegetable, and nut farms across the country needing pollination. The season often starts in California with the nearly 1 million acres of almonds and trillions of individual blossoms. (This is considered the largest single pollination event on the planet.) From there bees go on to assist with the pollination of other crops across the nation.

Honeybees

A Caste of Sorts

Honeybees are social insects that live together in large, highly organized colonies. Each typically consists of tens of thousands of individual bees, and individuals perform a variety of complex tasks that help the colony function, survive, and reproduce.

Labor is divided between three types of adult bees, each with specific and important roles to play. Workers dominate the population. This all-female labor force is responsible for, among other things, nest construction and maintenance, colony defense, food collection, and rearing young. Drones are males and by far the largest bees in the colony. Their chief role is to mate with a virgin queen to ensure the production of new colonies.

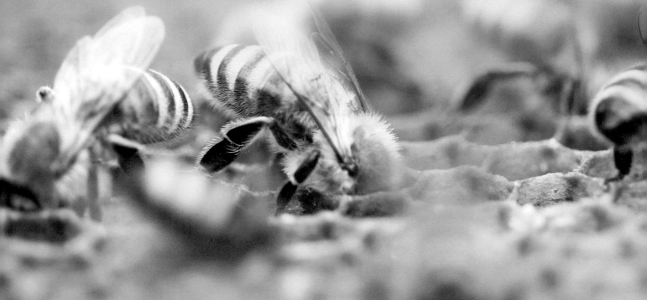

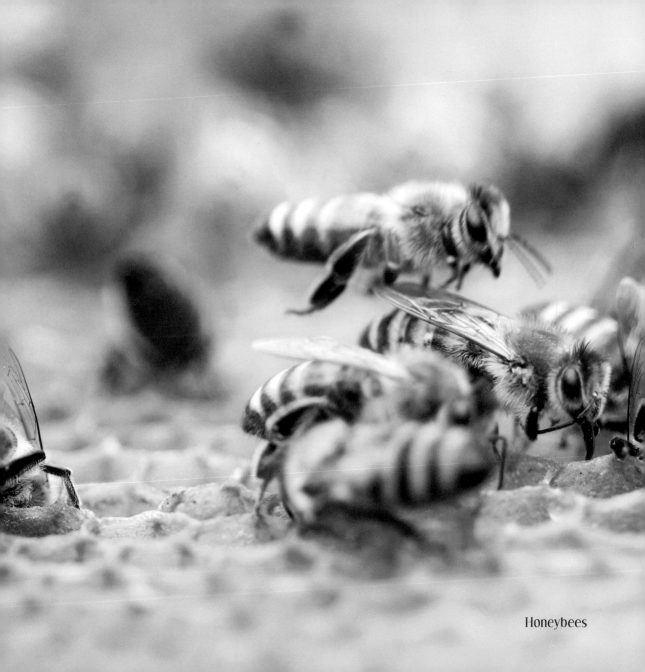

Honeybees

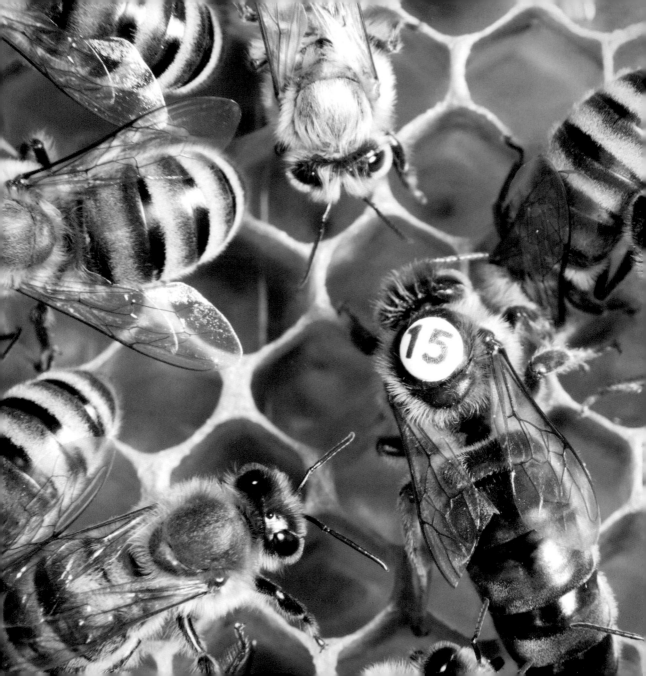

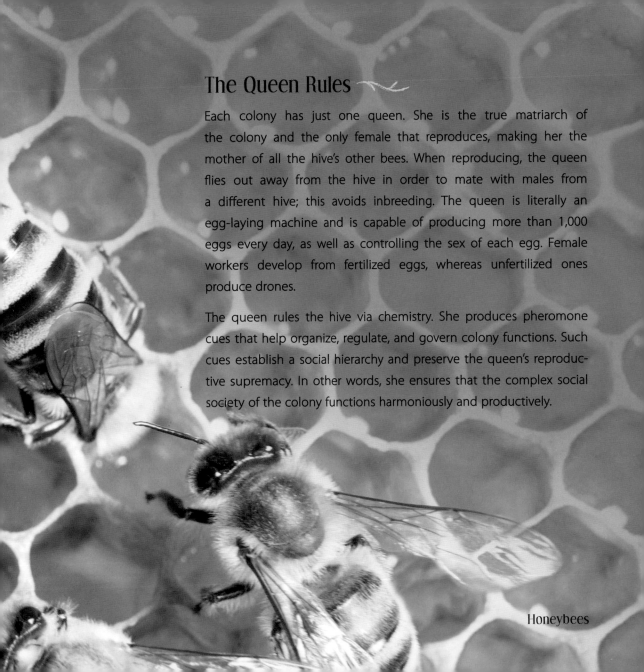

The Queen Rules

Each colony has just one queen. She is the true matriarch of the colony and the only female that reproduces, making her the mother of all the hive's other bees. When reproducing, the queen flies out away from the hive in order to mate with males from a different hive; this avoids inbreeding. The queen is literally an egg-laying machine and is capable of producing more than 1,000 eggs every day, as well as controlling the sex of each egg. Female workers develop from fertilized eggs, whereas unfertilized ones produce drones.

The queen rules the hive via chemistry. She produces pheromone cues that help organize, regulate, and govern colony functions. Such cues establish a social hierarchy and preserve the queen's reproductive supremacy. In other words, she ensures that the complex social society of the colony functions harmoniously and productively.

Honeybees

Working Together as One

More than just an assemblage of individuals, a honeybee colony has often been described as a superorganism—a collective intelligence of sorts, all working together and functioning like a single organism. Collaboratively, the hive controls all key colony functions, including reproduction, maintenance, temperature regulation, and even air exchange.

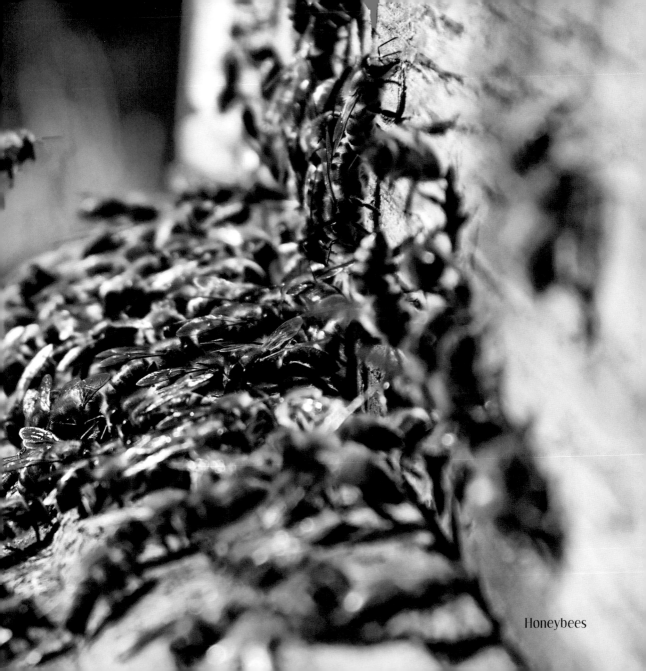

Honeybees

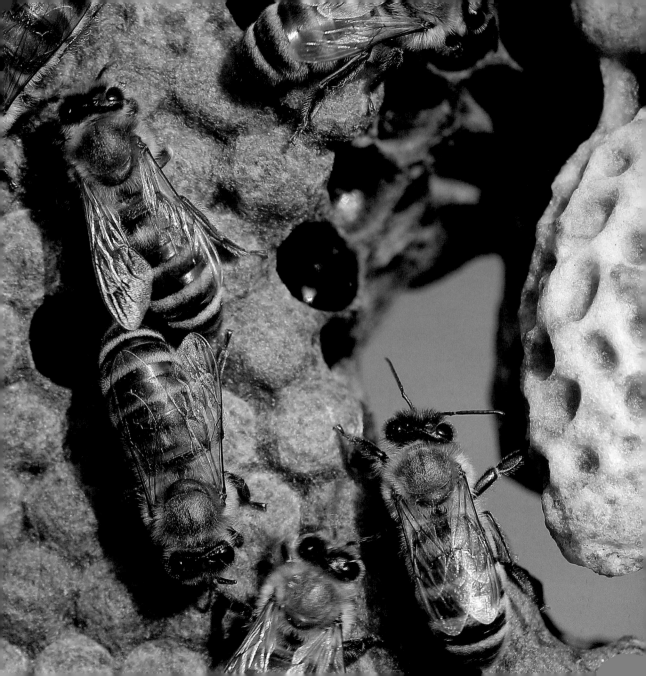

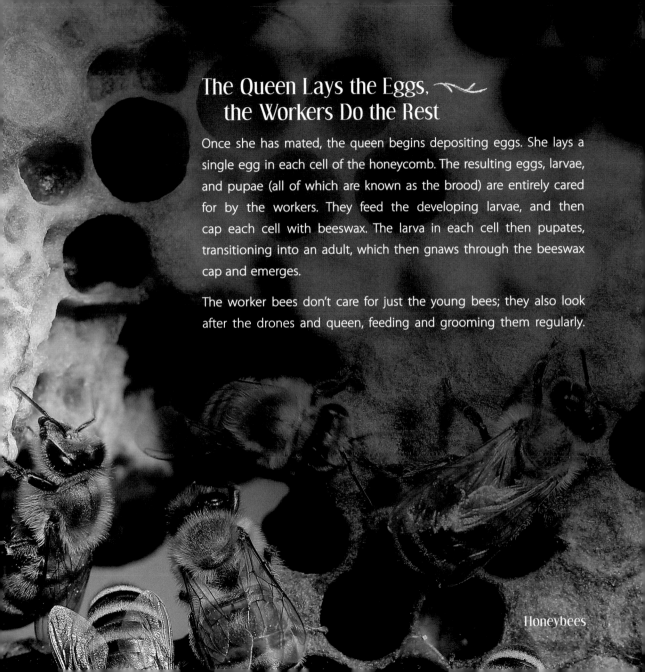

The Queen Lays the Eggs, the Workers Do the Rest

Once she has mated, the queen begins depositing eggs. She lays a single egg in each cell of the honeycomb. The resulting eggs, larvae, and pupae (all of which are known as the brood) are entirely cared for by the workers. They feed the developing larvae, and then cap each cell with beeswax. The larva in each cell then pupates, transitioning into an adult, which then gnaws through the beeswax cap and emerges.

The worker bees don't care for just the young bees; they also look after the drones and queen, feeding and grooming them regularly.

Honeybees

Hunters and Gatherers

For a hive to flourish, it needs adequate food, water, and raw materials. That's where worker bees come in; they are responsible for finding and acquiring resources. Like a small army on the advance, they actively search throughout the surrounding landscape and collect flower nectar, pollen, water, and sap to bring back to the colony. (So if you see a bee, chances are very good it's a worker bee.)

Sugar-rich nectar provides bees with an immediate energy source. Nectar is also the raw material for honey, the essential food reserve of any colony. Bees collect pollen because it provides a wide range of nutritional benefits, and it's an excellent source of protein. Together, a productive colony may gather 50 pounds of pollen each year. For perspective, the average pollen load carried by a single bee is around 8 milligrams; obtaining 50 pounds of pollen takes approximately 2.8 million trips.

But bees collect more than pollen and water. They also collect resin and sap from a variety of plant sources. Sap and resin are used to create propolis, a sticky and extremely strong substance that serves to help seal gaps and reinforces the hive's overall structural integrity.

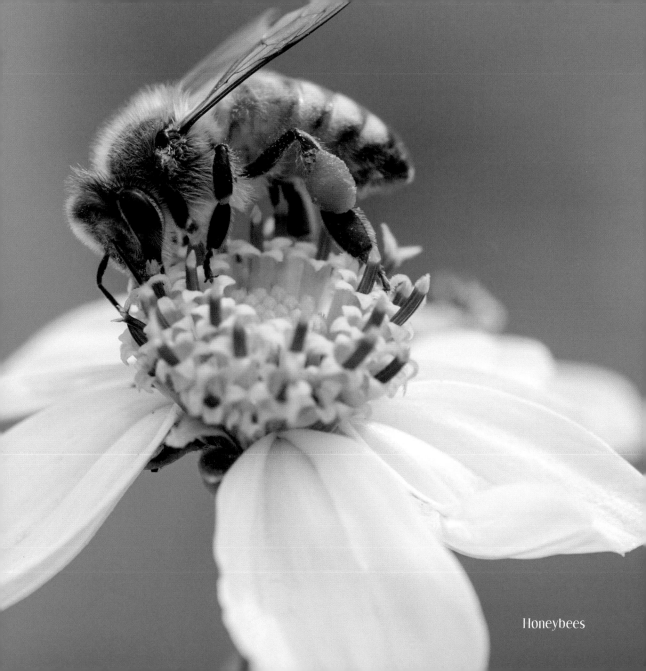

Honeybees

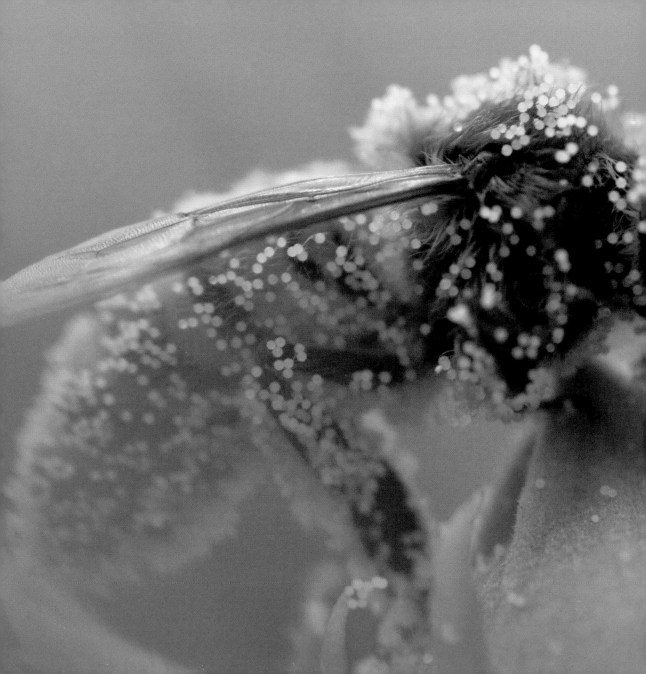

An Evolutionary Success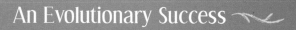

Honeybees have evolved to become incredibly efficient pollen collectors. They have a variety of specialized anatomical features that help maximize the amount of pollen they gather and transport. During a flower visit, pollen rubs off on their noticeably fuzzy bodies. This pollen sticks in part because bees have a static cling: as their wings whir, the bees develop a positive electrostatic charge. When the bee lands, this static charge causes pollen, which is negatively charged, to stick to the individual hairs.

Much like a grooming cat, the bee then uses its legs to brush the hairs. Stiff pollen combs on the hind legs carefully remove the many individual pollen grains, which are then neatly packed into dense clumps before being placed in yet another specialized structure on the hind legs—called a pollen basket—for easier storage during flight. The resulting engorged yellow-orange saddlebags are quite distinctive.

Busy as a Bee, Indeed

Although the distance an individual bee flies in search of nectar and pollen varies depending on the quality and quantity of the flowers available, a single worker may venture over 2 miles from the colony. An individual worker may take a dozen or more foraging trips per day, visiting hundreds of flowers in the process. Workers tasked with collecting water may make considerably more trips in support of the colony.

Collectively, the numbers are staggering. A productive colony may produce more than 100 pounds of honey each year. A yield of just 1 pound requires the combined foraging efforts of over 500 workers, some 2 million flower visits, and tens of thousands of miles traveled—enough to circumnavigate the globe twice.

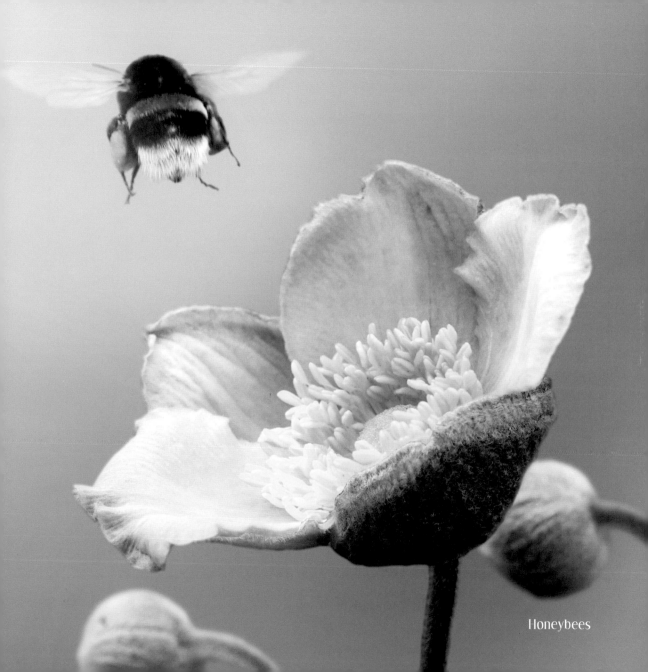

Honeybees

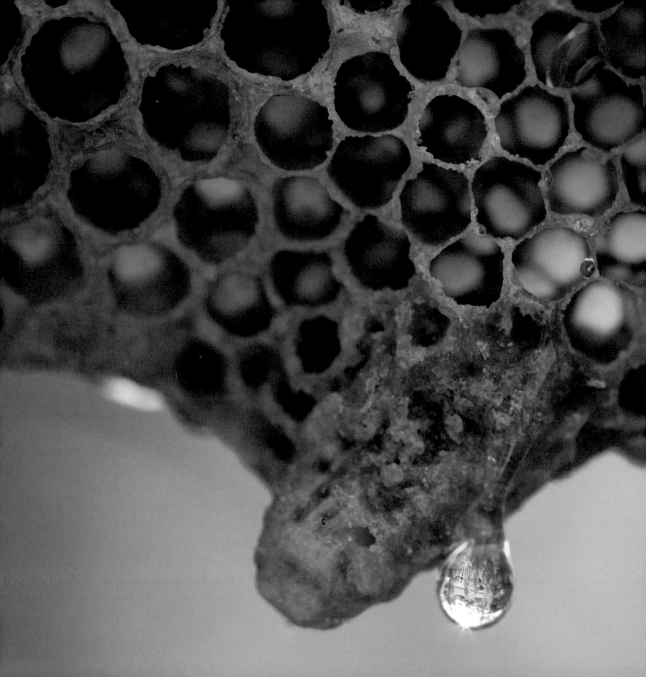

Bees and Honey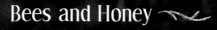

The sweet, golden syrup known as honey is produced from flower nectar. When bees visit a flower, they collect nectar by ingesting it. During the process of collecting, transporting, and depositing the nectar, bees add enzymes (chemicals that speed up chemical reactions) to it. It is then safely placed in honeycombs before additional moisture is removed. Like an industrial fan, the industrious bees beat their wings to accelerate airflow and aid the evaporation process. Once the honey inside thickens, the honeycomb is sealed so the honey is safely stored for use over the winter months when no flower nectar is available for bees to eat.

The honey from each hive is unique. Just as the fragrance of different blossoms varies, so does the flavor and color of honey based on the flowering plant from which the nectar was originally collected. Common nectar sources for bees include clover, alfalfa, dandelion, and willows and maples, among many others. Across the U.S., the combined effort of these industrious insects in over 2.5 million hives produces millions of pounds of honey for consumption and use in medicines (wound care) and cosmetics.

Honeybees

The Language of Dance: Honeybee Communication

The landscape outside a honeybee colony is complex and challenging to navigate. Once a worker bee finds a good source of food, she must tell her nestmates exactly how to find it. This is accomplished with a theatrical show of sorts—the waggle dance —a unique form of communication that enables bees to tell other members of the hive where to find resources. When performing a waggle dance, a bee traces a figure-eight shape; during the middle portion of the figure eight, it waggles. The amount a bee waggles communicates the distance of the food source (more waggling means a more distant food source); the angle at which the bee holds its body while waggling indicates the direction of the sun.

Just like a GPS, the elaborate dance routine conveys detailed directions and the exact distance to the destination, as well as specifics on the resource's overall quality. In fact, bees tend to dance more for the better floral resources and can even adjust their selectivity among nectar sources based on the nutritional needs of the colony.

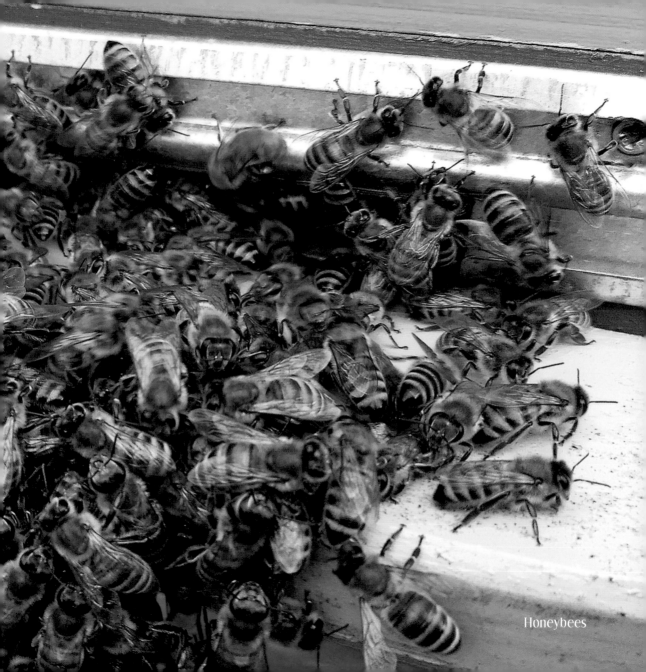

Honeybees

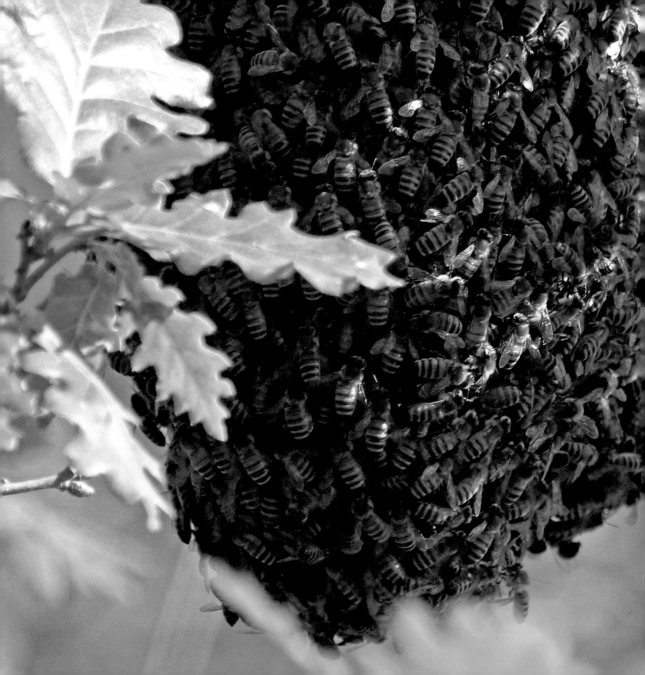

Harnessing the Power of the Swarm

Although somewhat reminiscent of a bad horror movie, swarming bees are not planning an attack. Rather, they are simply looking for new, roomier accommodations. Honeybee colonies can grow rapidly during the warm months of the year, and this means they need more space to accommodate their growing population and storage needs.

When conditions become too cramped, the existing queen and many of her loyal workers simply leave. The resulting swarms can contain thousands of bees and are the foundation of a new colony. Those left behind produce a replacement queen and the mantle of governance is successfully passed along. This is the natural reproductive cycle of any living honeybee colony.

More Than Just the Honeybee: ∿
Our Native Bees

The faces of pollination are diverse. Although the western honeybee often gets most of the attention, it is just one of more than 20,000 different bee species found throughout the world. North America alone boasts nearly 4,000 different native bees, all of which were residents long before early colonists brought honeybee hives over from Europe.

Native bees come in an amazing variety of sizes, colors, and forms. They have many different behaviors, preferences, geographic ranges, and traits. While most quietly go about their business entirely unnoticed, when it comes to pollination, they are as important as honeybees.

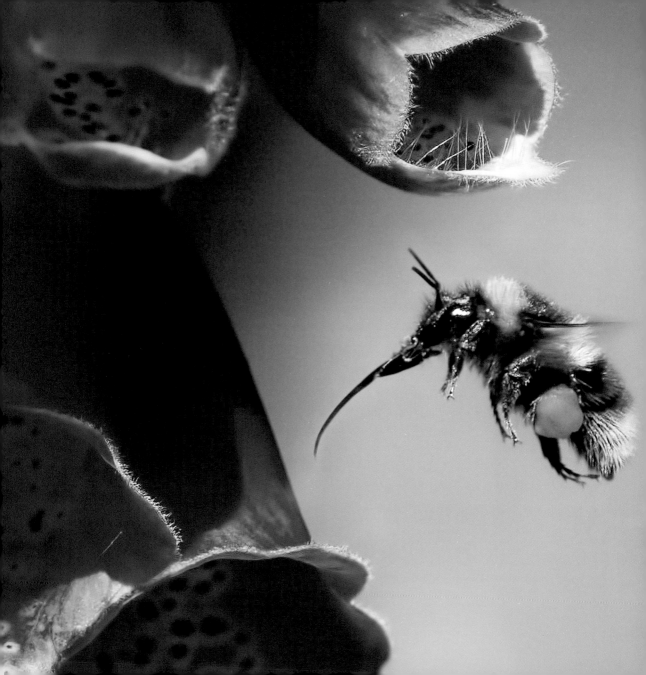

Bumblebees: Our Social Native Bees ～⌇

Easily recognizable based on their stout, fuzzy appearance, bumblebees are the only truly social native bees in North America. (Bees that live in groups/hives are referred to as social bees; bees that live alone are solitary bees.) Just like the western honeybee, they live in complex societies with a distinct division of labor and multiple, overlapping generations. But their colonies are much smaller in size and have a more limited lifespan, surviving only for a single season in temperate regions. By contrast, honeybee hives typically endure for two to five years.

Unlike in honeybee hives, when fall approaches, newly emerged young bumblebee queens leave the nest to mate, and the remaining colony, including the old queen, dies. These young matriarchs hibernate over the winter and emerge in spring to start new colonies. They seek out existing cavities, and they have a particular predilection for underground spaces. Once a cozy home is located, each queen begins the arduous task of building a new empire.

Solitary Lifestyles

Unlike the bumblebee, the vast majority of native bees lead solitary lives. Like other organisms, bees are intensely focused on reproduction. A great many solitary bees nest in the ground. The female excavates individual subterranean tunnels, each with many chambers, and provisions them with pollen and nectar for her developing young to eat. Once outfitted with sufficient resources, she moves on and her young develop on their own with no additional maternal care.

Other solitary bees, such as carpenter or leafcutter bees, seek out existing structures. They construct nests in hollow twigs, empty cavities, or holes bored in wood. They add food resources just like their subterranean-dwelling sisters, but they create individual brood cells in a linear fashion much like the rooms in a hotel.

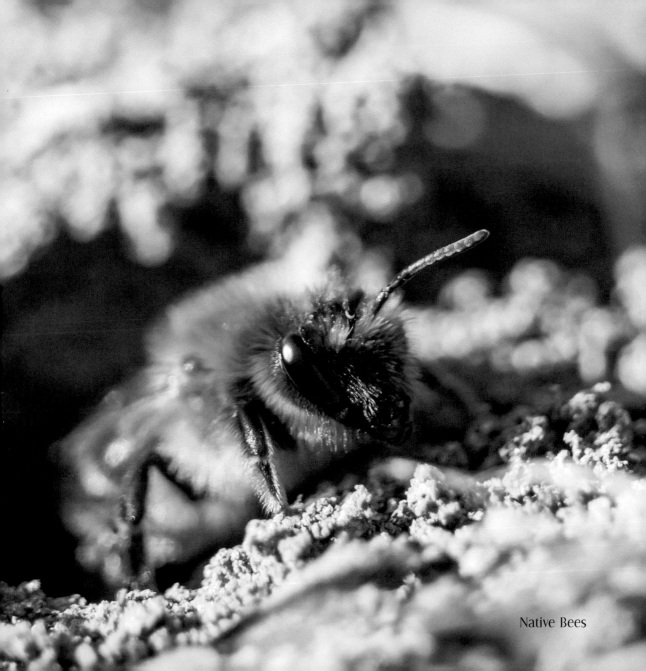

Native Bees

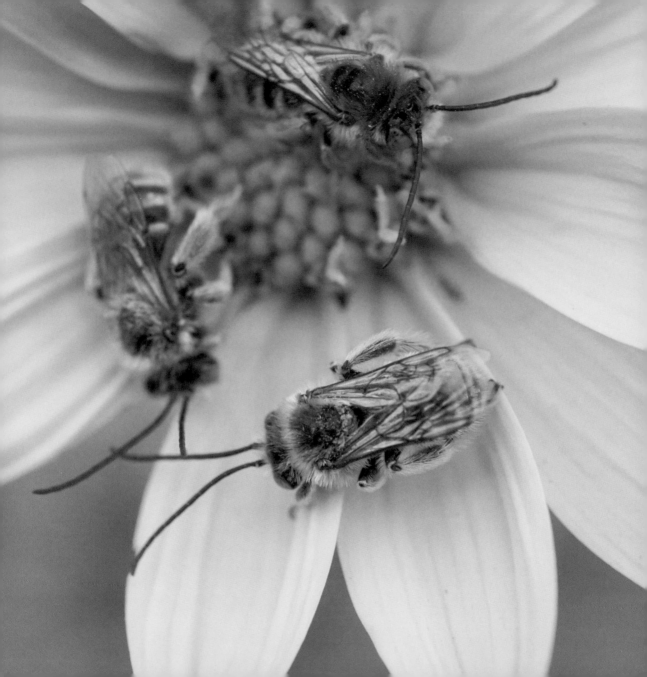

Dietary Preferences

When it comes to menu choices, native bees often have distinct pollen preferences. The majority, such as bumblebees and long-horned bees, are generalists. Like a hungry patron visiting a buffet, they seek resources from a broad array of different flowers. As they are not restricted to any particular flower host, they tend to be much more common, widespread, and resilient in response to environmental changes.

In contrast, some native bees, such as mining and sunflower bees, are very picky eaters. These dietary specialists have evolved exclusive relationships with a select few or even just one, particular flowering plant species. This association is quite intimate and requires the bee to be active when the particular plant is in flower. In some cases, the flower itself may rely exclusively on the bee for its pollination. Specialist bees tend to be less common, limited to the range of their host, and often vulnerable to habitat destruction.

Unwelcome Invaders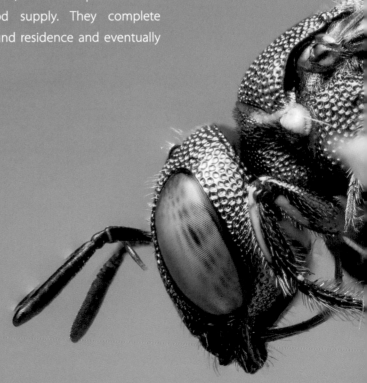

Some native bees have evolved somewhat sinister behaviors. Just like the bird of the same name, Cuckoo bees seek out the well-provisioned nests of others. When an unsuspecting owner is out, the stealthy invader enters and deposits her eggs within the victim's nest. Once the cuckoo bee eggs hatch, the young larvae actively seek out and destroy the host's offspring. With the field now clear of any unwanted competition, the interlopers are free to consume the stored pollen food supply. They complete development in the hijacked underground residence and eventually emerge as adults.

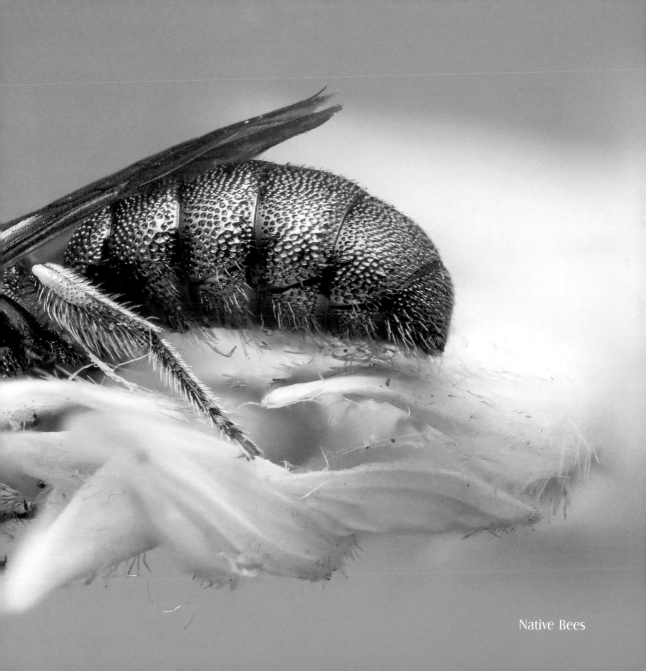

Native Bees

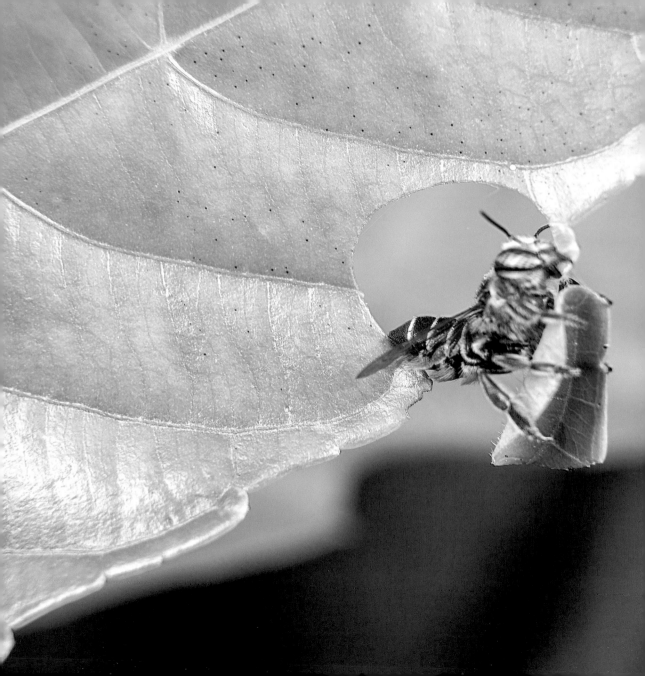

Leaf Cutters

The distinctive signs left behind by these bees in the garden and woods are obvious. Like diminutive crafters, leaf cutter bees neatly cut circular sections out of plant leaves. To do so, they make use of their highly specialized, scissor-like jaws.

Each resulting fragment is carried back to their nest and used to systematically line the interior of an existing cavity or a hollow twig. In the process, they create elongated, papery brown tubes that somewhat resemble cigars. When construction is complete, the hardworking bee adds the final touch by skillfully sealing off the opening to safely secure her developing brood.

Working in Wood

As their name implies, carpenter bees are expert wood carvers. They use their hard mandibles like a drill bit to bore precise, rounded tunnels into wood. During excavation, there is audible chewing along with telltale signs of fine sawdust below the burrow.

Although carpenter bees occasionally mar man-made structures, they seldom inflict any structural damage and most often prefer untreated wood in which to construct their nests. They naturally utilize dead trees or similar vegetative debris and can regularly be attracted with artificial nest structures such as plain wooden blocks or posts.

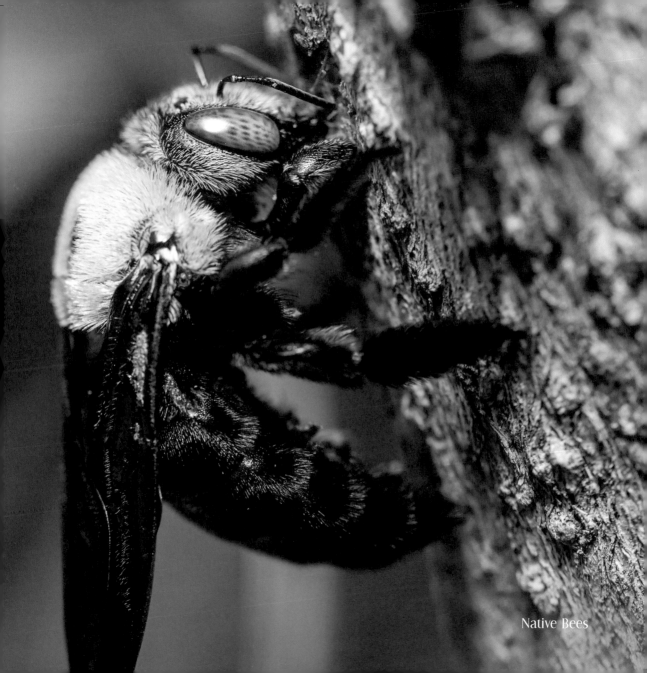

Native Bees

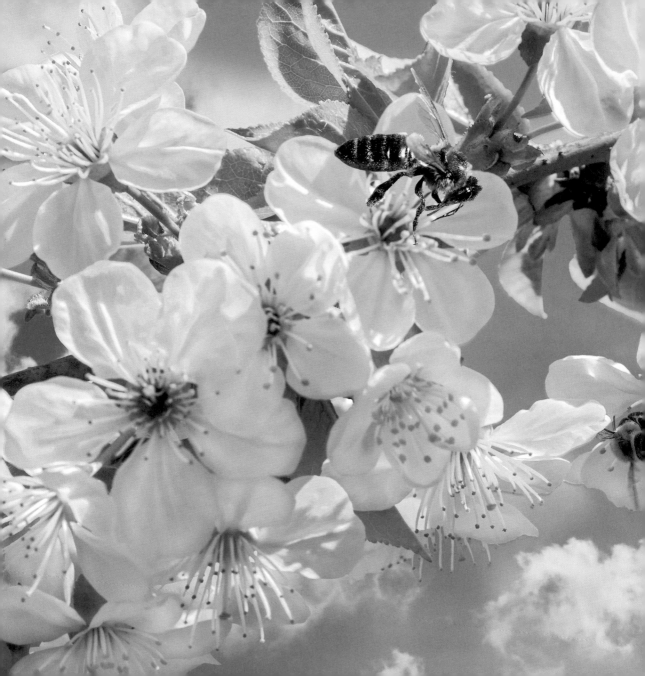

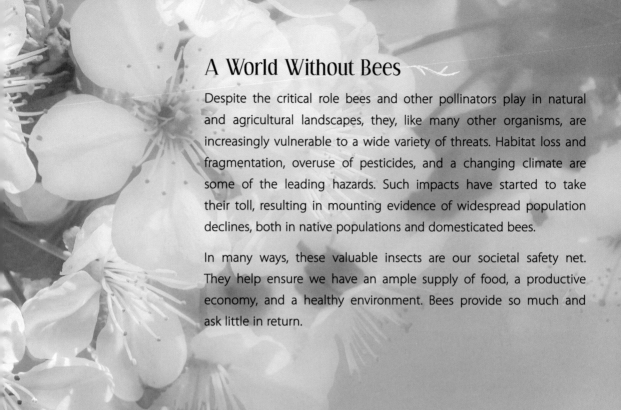

A World Without Bees

Despite the critical role bees and other pollinators play in natural and agricultural landscapes, they, like many other organisms, are increasingly vulnerable to a wide variety of threats. Habitat loss and fragmentation, overuse of pesticides, and a changing climate are some of the leading hazards. Such impacts have started to take their toll, resulting in mounting evidence of widespread population declines, both in native populations and domesticated bees.

In many ways, these valuable insects are our societal safety net. They help ensure we have an ample supply of food, a productive economy, and a healthy environment. Bees provide so much and ask little in return.

Community Conservation and What You Can Do

Bees don't require very much to be happy. They need a variety of flowering plants that provide pollen and nectar resources throughout the growing season, access to available nesting sites, and limited pesticide use. When it comes to effective conservation, every landscape matters, and no site is too small.

Bee-friendly sites can range from suburban gardens spanning several acres to just a small container showcasing a few blooming plants; it all matters. By creating bee-friendly spaces, together we can make a real impact; in the process, we'll all get new opportunities to watch and learn about these fascinating, essential creatures.

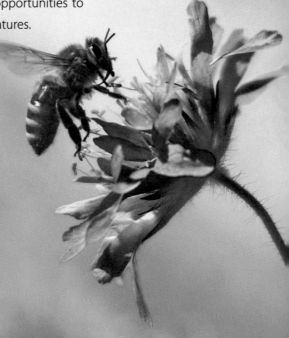

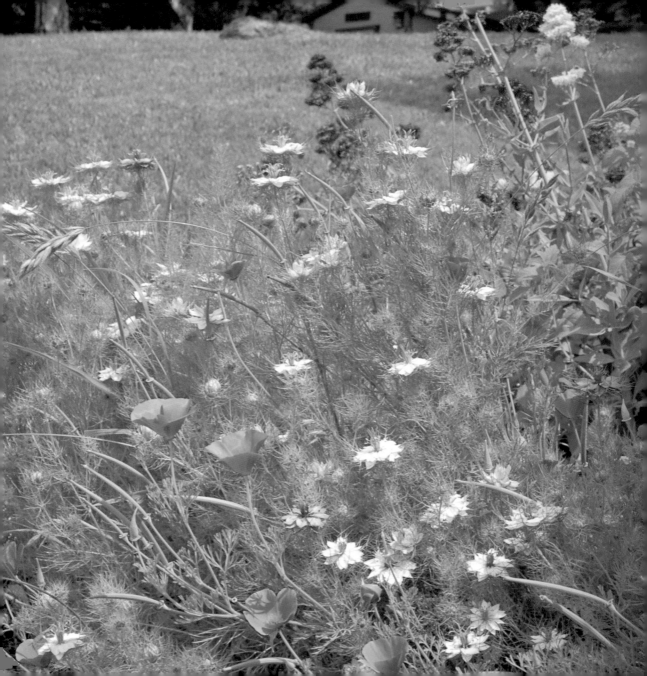

Help Make Your Yard Bee-Friendly

Most bees have relatively simple requirements. They need abundant forage resources for access to pollen and nectar, nesting resources, and limited pesticide use. To help make your landscape more bee-friendly, here are a few simple tips:

- Include a variety of blooming plants that vary in flower color, shape, and size.

- Use native plants.

- Select plants that bloom throughout the growing season.

- Maintain nesting resources. This includes semi-bare, untilled ground, brush piles, and snags. Artificial nest boxes may also be provided. They are a fun and easy way to make nesting sites available to wood-nesting and cavity-nesting species.

- Minimize pesticide use.

The diversity of flowering plants available on the market is extensive. While there is no perfect list, here are some that are particularly bee-friendly: sunflowers, asters, blazing star, foxglove, mint, purple coneflower, sedum, clover, coreopsis, beebalm, poppies, Joe Pye weed, spirea, ironweed, lavender, rosemary, black-eyed Susan, cosmos, blanket flower, lupine, wild lilac, and anise hyssop.

About the Author

Jaret C. Daniels, Ph.D., is an Associate Professor of Entomology at the University of Florida and Director of the McGuire Center for Lepidoptera and Biodiversity at the Florida Museum of Natural History, specializing in insect ecology and conservation.

He has authored numerous scientific papers, popular articles, and books on wildlife conservation, insects, and butterflies, including butterfly field guides for Florida, Georgia, the Carolinas, Ohio, and Michigan. He is also the author of *Vibrant Butterflies: Our Favorite Visitors to Flowers and Gardens* and *Backyard Bugs: An Identification Guide to Common Insects, Spiders, and More*. Jaret currently lives in Gainesville, Florida, with his wife, Stephanie.